W9-AVC-296

This library edition published in 2013 by Walter Foster Publishing, Inc.
Walter Foster Library
3 Wrigley, Suite A, Irvine, CA 92618

Printed in Mankato, Minnesota, USA by CG Book Printers, a division of Corporate Graphics.

First Library Edition

Library of Congress Cataloging-in-Publication Data

Rosinski, Carol.
 Getting started / By Carol Rosinksi.
 pages cm. -- (Drawing made easy)
1. Drawing--Technique. I. Title.
 NC730.R59 2013
 741.2'4--dc23

 2013011654

052013
18134

9 8 7 6 5 4 3 2 1

GETTING STARTED

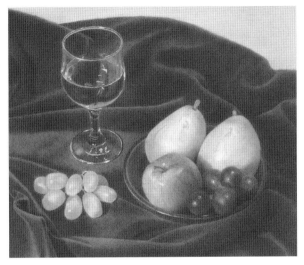

By Carol Rosinski

www.walterfoster.com

CONTENTS

Introduction. 3

Getting to Know Your Tools . 4

Warming Up . 10

Using Line, Shape, and Form . 12

Drawing What You See . 16

Shading Techniques . 20

Deciding What to Draw . 24

Working from Life or Photos . 26

Using Your Computer . 30

Light and Shadow Basics . 32

Composition Basics . 34

Perspective Basics . 36

Texture Basics . 38

Rendering Detail . 42

Project 1: Landscape . 44

Project 2: Horse . 48

Project 3: Floral Still Life . 52

Project 4: Portrait of a Girl . 56

Project 5: Fruit & Wine . 60

Closing Thoughts . 64

INTRODUCTION

Pencil drawing is the most simple and basic art form, yet the range of possible expressions is almost limitless. From energetic sketches of figures in action to simple studies of serene still lifes, drawing can capture time and movement, light and shadow, line, texture, and form—and so much more! As a pencil glides across paper, emotions can be recorded and memories preserved.

Drawing is affordable—a pencil, a piece of paper, and an eraser are all you need. And drawing is a skill that easily can be developed. Mastering the basic techniques is easier than you may imagine! With a willingness to learn and time to devote to practice, your efforts will be rewarded with a new way to express yourself.

This art form is an extraordinary gift you can give yourself and those around you!

GETTING TO KNOW YOUR TOOLS

The artist's greatest tool is the imagination. But before we start exercising this asset, it's important to get to know the range of tools that can act as extensions of your imagination, allowing you to transfer what's in your head to your drawing surface. All you really need to start are a pencil, eraser, and paper. But there are a few other items that will come in handy as well—and they're all explained here.

Pencils

Artist's pencils (A) contain a graphite center ("lead") and are sorted by hardness ("grades"), from very soft (labeled 9B) to very hard (labeled 9H). You don't need a pencil of every grade when you first begin drawing; a good starting collection is 6B, 2B, B, 2H, 4H, and 6H. Bear in mind that pencil hardness is not standardized, so one brand's 2H pencil might be the same as another brand's B (see "Pencil Key" on the next page). For this reason, I suggest that your first group of pencils be of the same brand. An alternative to wooden pencils are lead holders (B). Usually made of metal and plastic, *lead holders* resemble pencils but are actually hollow, reusable holders for individual leads. Purchased separately, the lead refills are placed in the holder, which has a clutch action near the tip to hold the lead tightly; when you press the opposite end, the tip releases, letting out as much lead as you need. Leads are about 5" long and 2mm in diameter; they usually are sold in packages of a dozen of one grade. Although lead holders are convenient and easy to use, beginners usually start with the more economical wooden pencils.

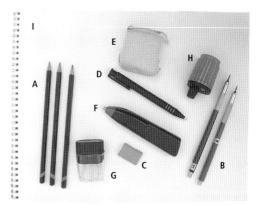

Purchasing the Essentials Your local arts and crafts store is sure to carry the basic items shown above. Keep in mind that it's best to purchase the highest quality materials you can afford, as these produce the best results.

Erasers

There are three basic types of erasers for use in pencil drawing: kneaded (C), stick (D), and pillow (E). *Kneaded* erasers are very soft and can be molded into different shapes. *Stick* erasers come in pen-shaped holders and easily can be carved into a point using a craft knife or razor blade. *Pillow* erasers are made of a loosely woven cloth filled with loose erasing material, allowing you to clean up smudges and accidental marks on large areas. For more information on eraser techniques, including using battery-powered or electric erasers (F), see page 8.

Sharpeners

If you are using wooden pencils, a simple hand-held sharpener (G) that catches the shavings is a good choice. Electric sharpeners also are great, as they quickly produce a very sharp tip. If you are using lead holders, be sure to buy the appropriate sharpener for your brand (H).

Papers

For practice sketches, purchase a medium-weight (50- to 60-lb) paper pad, which is bound with tape or a wire spiral (I). For more finished drawings, buy a heavy-weight paper (about 70- to 80-lb). Most paper is made from cotton fibers (rag) and/or wood pulp, but you also can buy recycled papers. Wood pulp papers are the least expensive and are great for beginners. Cotton fiber papers are more expensive but also are more durable. Paper texture (the "tooth") also varies: *Plate* or *hot-press* paper is smooth and allows for softer blends and smooth shading, whereas *vellum* or *cold-press* paper is rough and allows for strokes with more texture.

Brushes

Brushes aren't usually thought of as a drawing tool, but they can be extremely useful for creating smooth blends and gradations and for applying graphite dust directly to the drawing surface. You can use any flat, soft-bristle paintbrush for this method. Small brushes with short bristles allow for more accuracy, so you may have to trim the bristles to the desired length with a small pair of sharp scissors.

◄ **Trimming Bristles** When trimming the bristles of a paintbrush, cut the bristles at a slight angle (you'll be holding the brush at an angle to the paper). The trimmed brush has stiffer bristles that give you much more control when working with graphite.

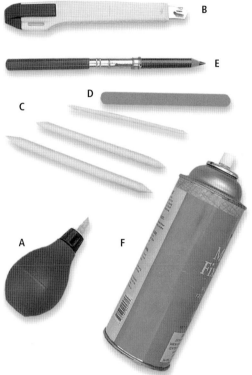

Extras

The materials on these pages are only the basics—there are many other items (some of which are shown at right) that may be of assistance as you draw. A *blow bulb* comes in handy for blowing away loose graphite dust and eraser crumbs without disturbing the drawing beneath (A). A small craft knife is an ideal tool for shaping erasers (B). A *blending stump*—soft paper packed into the shape of a slim cylinder—is used for smearing and blending (C). Emery boards can sharpen pencils and help you create piles of loose graphite (D). *Pencil extenders* add length to your short pencils so you can grip them properly (E). And *spray fixative* prevents your finished piece from smudging (F). It's also a good idea to purchase a plastic toolbox with a handle to store your tools between drawing sessions.

▲ **Gathering Additional Items** Most of the items pictured above easily can be found at your local arts and crafts store. Others, such as tissues and cotton swabs, you may already have in your kitchen or bathroom!

Pencil Key

Because pencil hardness varies from brand to brand, the exercises and projects often generically call for "hard" or "soft" pencils. Use the conversions at right to help determine which pencils to use in the projects of this book.

- Very hard: 4H–6H
- Hard: 3H–4H
- Medium hard: H–2H
- Medium: HB-F
- Medium soft: B–2B
- Soft: 3B–4B
- Very soft: 4B–6B

Setting Up Your Workspace

Choose your workspace to match your style. Some people like to use stands to allow free arm movement; others sit at a table for more precise work; and some, like me, prefer to sit in a stuffed chair. Select an easel, table, or lap desk to hold your paper while you draw. Wherever you do your drawing, you will need good lighting: a floor lamp, desk light, or clamp-on light. As an artist, you may prefer to use a "natural" or "daylight" bulb, which mimics sunlight and is easy on your eyes. To avoid blocking the light with your body or hand—if you are right-handed—place the light to your left and above your work; left-handed artists, put your lamp to the right and above.

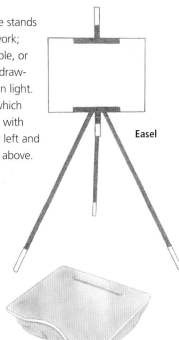

Easel

Lap Desk A laptop board with a pillow attached beneath allows you to put your feet up, lean back, and draw.

Drafting or Drawing Table You can angle these tabletops for comfort. If space is short, get a table that folds for storage.

Easel An easel will hold your work upright, so you can work standing or sitting.

Drafting table

Lap desk

Caring for Your Drawings

The rich quality of graphite makes it possible to create beautiful and realistic effects. But graphite smears easily, and drawings require care in handling. Between drawing sessions, cover your work with a piece of plastic food wrap that is a few inches longer than the length of the board; tape it to the back of the drawing board; and flip it to the back of the board while drawing. To store drawings until they're framed, consider archival plastic bags that hold several drawings. Separate each item with 100% cotton paper; then lay the bags flat for storage out of direct sunlight.

Drawing on the Go

The outdoors provides fresh air and plenty of artistic inspiration, from streets and buildings to trees and flowers. Make a portable drawing kit to take along on your outdoor adventures. Book bags are just the right size for 8" x 10" or 10" x 12" drawing tablets and often have several compartments for holding tools. Because drawing tools are inexpensive, you may even want to assemble an extra kit that you use exclusively for drawing outdoors! You also may consider bringing along a fold-up stool for comfort.

Applying Graphite

Use the following images and techniques as a guide to become familiar with the basics of using graphite—from gripping the pencil to using a brush. The more you practice applying the graphite, the better you'll be able to manipulate it to achieve the effects you desire.

Holding the Pencil

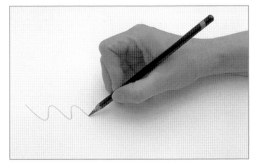

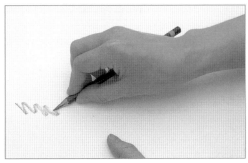

Handwriting Position Pinch your index finger, thumb, and third finger around your pencil securely as if writing a letter. This position gives you great control to create precise lines.

Underhand Position Clasp the pencil lightly with your fingertips, holding the pencil under your hand. You will be able to draw loose, flowing strokes with minimal effort.

Working with Powdered Graphite

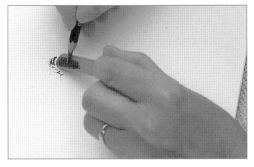

Step One Powdered graphite, or graphite dust, is ideal for rich, soft shading. Rub a soft pencil lead over an emery board to create a small pile of powdered graphite.

Step Two Now load your brush with graphite and stroke it over a piece of scrap paper. Practice creating soft shading, dark lines, and velvety smooth areas.

Blending

There are a number of ways to create blends in your graphite drawings. At right are two examples of the use of simple blending tools: a brush and a tissue. You'll find that each process yields different results, so use the one that best suits your subject. (Avoid using your finger to blend, as this can release unwanted oils from your skin onto your drawing surface.)

Blending with a Brush
Stroke with a medium-hard pencil (bottom); then use the brush to push around the graphite (top).

Rubbing with a Tissue
Stroke with a medium pencil (bottom). Then wrap a tissue around your finger and rub it over an area (top).

Using Erasers

Graphite is very easy to manipulate with erasers. Not only can you correct mistakes, but you also can use them to soften lines, create lighter shading, pull out highlights, and even draw. The process of creating light areas or shapes on a darker graphite background is called "lifting out." The three basic types of erasers are featured at right. Let the effect you want to achieve guide your choice of eraser.

Stick eraser

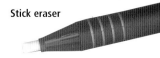

Kneaded eraser

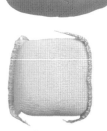

Pillow eraser

Stick Eraser Hold this eraser as you would a pencil. Trim the tip to a point or a sharp wedge, as shown.

Kneaded Eraser You can mold this puttylike eraser into any shape you need—large or small, pointed or blunt.

Pillow Eraser This cloth-covered tool is made of tiny pieces of eraser that are released through a loose weave, allowing you to lift out large areas of graphite.

Lifting Out Mold your kneaded eraser into a blunt edge and touch the paper lightly. When you lift up, you'll leave behind subtle variations of light that are appropriate for soft highlights.

Forming Patterns Roll the kneaded eraser into a sharp tip and dab at the graphite-covered surface in a jabbing motion. This can produce a light, patterned effect.

Pinching Shapes Pinch your kneaded eraser into a wedge shape to create soft, crescentlike areas; this is ideal for lifting out highlights in curly hair or creating subtle folds in fabric.

Drawing Shape a kneaded eraser; then gently press down and lift up and away. Repeat if needed. Then accent your shapes with pencil strokes to make them seem to pop off the paper.

Creating Detail With the sharp point of a stick eraser, stroke or draw into the graphite to reveal the paper underneath for intricate details, such as highlights on water or metal.

Stroking Lines Cut a stick eraser's tip into a wedge. Use the edge lengthwise and pull to erase long, sharp, crisp lines for objects such as leaves, stems, or twigs.

Working with a Battery-Powered Eraser

The spinning point of a battery-powered eraser can create fine details with little effort. "Draw" with this eraser by holding it like a pencil. You quickly can create clear contrasts between light and dark areas, providing sharp edges and areas of focus. Lift out small reflections, produce sparkles on snow, or suggest the shiny texture of metal. Use a metal erasing shield for precise shapes.

Practicing with Your Tools

It's easy to learn how to draw by experimenting. So gather your materials and get ready to have fun! To get you started, try the exercises shown here. Then use these images as inspiration for your own experiments. Remember that your doodles don't have to look like the real subjects—just become familiar with the feel of the pencil against the paper. Be sure to play with different grades to see how soft and hard leads respond to the paper. Try different brushing techniques, and use your eraser too.

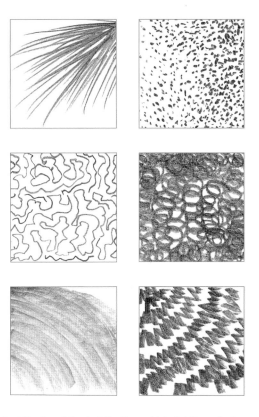

Try Out Different Pencils Make a scribble-art design and fill it in using different grades of pencil. Making these marks side by side will help you become familiar with the different pencil grades, as well as the pressure you need to apply to create a specific value, which is the relative lightness or darkness of the graphite.

Feel the Pencil Against the Paper Make fluid lines, short lines, zigzagged lines, swirls, dots, and continuous circular lines. Use both the point and side of your pencil. Notice how the pencil feels on the paper as you make different kinds of lines and marks. Let your wrist and arm move freely as your pencil meets the paper, and try out a variety of strokes with different grades of pencils. (The doodles above left were made with a 2H pencil; those above right were made with a 2B pencil.)

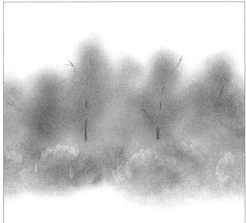

Pull Out Forms Brush a sheet of white paper with loose graphite to create toned paper. Shape a kneaded eraser and pull out the graphite to create a scene; then use a pencil to add darker outlines.

Create and Define Shapes With a brush and loose graphite, make a line of distant trees. Draw some bushes in front by lifting out the tops with a kneaded eraser. Then use a soft pencil to stroke in some trunks and limbs.

WARMING UP

Many artists do some warm-up exercises to get into the mood
for drawing. Simply moving the pencil to follow the shapes of your
subjects is good for building up a sense of control for your drawing
sessions. Here are a few examples of my personal warmups, which
you can use as models for your own. Although I've been drawing
for many years, I still need to warm up and get focused!

▶ **Finding a Location** This is my favorite chair and the place where I am most
comfortable. Drawing can be done anywhere. Just make sure you have a good,
consistent light source and that you are relaxed and content.

Choosing a Subject

When you are ready to warm up, you don't have to spend too
much time worrying about what to sketch—just look around
you! There are plenty of items nearby that are just waiting for
you to draw them, from pots and pans to books on a shelf. The
goal isn't to end up with a great project; it's the process that
counts—adjusting the outlines, seeing the shapes within the
objects, and recognizing the relationships between objects.

◀ **Finding a Focus** When you don't have a particular subject in mind, draw
whatever is right in front of you—even your own two feet!

Exercise One: Sketching

Start by making large, loose lines to block in your subjects. With each sketch, refine your lines to
become more accurate in stroke. Don't worry about getting the shape of your subject perfect; focus
on *finding the shape* through all of your movements with the pencil.

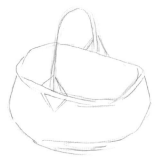

▼ **Sketch Two** After I have completed
one warm-up sketch, I feel more relaxed
and confident. My second basket starts
to take form, and the outlines are more
accurate.

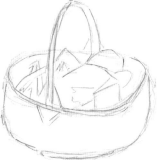

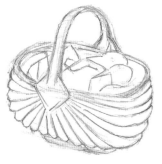

▲ **Sketch One** Here is my first warm-
up drawing of a sewing basket. Notice
the loose, rough lines—I have to draw
several lines to "find" the correct shape
of the basket.

▲ **Sketch Three** This basket is the
result of a later warm-up session. For the
third sketch, I don't worry about shading
or applying detail to my subject—I simply
refine the lines.

Exercise Two: Contour Drawing

Contour drawing is recording the outlines or edges of a subject—when you do this without looking down at your paper, it's called "blind contour drawing." This type of drawing is not about perfection—it's simply an exercise that helps coordinate your hand, mind, and eye to capture the angles and curves of your subject. Start by choosing an object to draw. As your eyes follow the shape of your subject, draw the lines you see without looking at your paper. This will ensure that you're drawing only what you see!

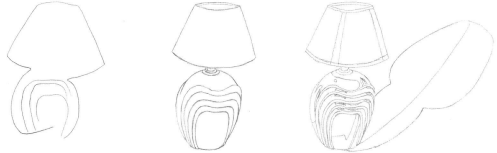

Contour One As you draw without looking at your paper, remember to focus on the silhouette and not on your results. Remember: It's the process that counts—the communication of your eyes to your pencil as you draw the object's outline.

Contour Two Now look at the object and your paper as you draw. Your sketch will be a more accurate representation of the subject, with all of the most important outlines.

Contour Three For the third phase of the warmup, again look at your paper and the object. Study your subject carefully and draw not only the contours and shapes, but also the value outlines (including the cast shadow) and most obvious details. Draw quickly and keep your hand relaxed.

Exercise Three: Gesture Drawing

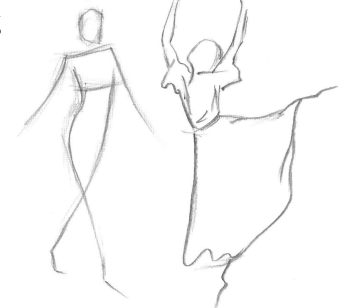

Gesture drawing generally refers to sketching figures in action. But it also can be a quick drawing of an object. Whatever the subject, the key is to capture its essence in a few seconds. Detail is unimportant; look more at your subject than at your drawing. Feel the structure and movement of line as you use the pencil. When gesture drawing, use your whole arm—your elbow needs to move without much shifting of your wrist.

Establishing a Gesture Gesture drawing is perhaps the most important of the warm-up exercises to employ before drawing figures, as it helps capture the movement of the body. As you create this type of sketch, refrain from shading or adding details.

USING LINE, SHAPE, AND FORM

The art elements line, shape, and form help us define our drawing subjects. These three elements are closely related. When actual or implied lines meet to enclose a space, they create a flat (two-dimensional) shape. A shape's boundary is delineated by actual line or by shading (varying values), color, or texture in or around it. *Form* is the three-dimensional illusion of depth created through the effective use of shading and overlapping.

▶ **Building a Structure** Making a good drawing is similar to building a house: First build a flat plan to follow (line); then erect the framework (shape); and finally put on siding and roof shingles (form).

▲ **Step One: Line Becomes Shape** Begin by sketching an accurate outline, which is a lot like a blueprint. This outline defines the basic shape of the subject and determines the plan for the rest of the drawing.

▲ **Step Two: Shape Becomes Form** Begin to develop the overlapping skeletal structure to indicate the shapes of the light and dark areas and the cast shadows. The three-dimensional form is beginning to be revealed.

▲ **Step Three: Form Is Enhanced with Value** Build on the structure with shading to create a three-dimensional appearance, suggesting that the candles are solid and real. The variations in lights and darks (values) describe the form.

Experimenting with Line

Line is the most basic of these three elements of art—it is the foundation of shape and form, as line is what delineates the space for each on a two-dimensional surface. There are many ways to create a line with graphite; you can use anything from a pencil or brush to your finger wrapped in tissue. Manipulate your tools to create a variety of line values, weights, and textures.

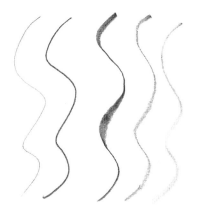

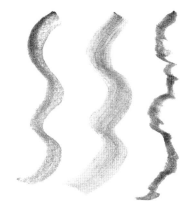

Working with Lines Make a thin line with the sharp point of a hard lead. A softer lead creates a less distinct line. Dip a stump into loose graphite and use it like a pencil to create soft, light lines.

Trying Variations When you use the side of a pencil, you can create thick, bold lines or light, fuzzy lines. A brush dipped in graphite powder makes a very soft, wide line.

Learning the Language of Line

Different types of lines can represent different qualities. For example, a soft, dark line might represent the shadow where an object sits on a surface. A thin, sharp line might outline the spot where light hits an object, creating a highlight. If your subject is soft, like a blanket, use soft leads and stumps to smooth your strokes and mimic the blanket's texture. If your subject is metal, draw it with hard leads to replicate its shiny, metallic surface. Experiment with your tools to recognize what each is capable of creating.

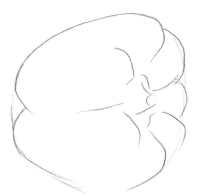

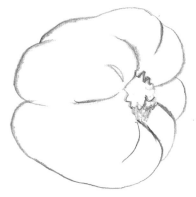

Blocking In As we discussed in the warm-up exercises, a contour drawing captures the outline of the subject. Add a few lines to suggest the general shape and establish a starting point for a more developed drawing.

Adding Weight Now make the drawing more suggestive of the actual object by using the language of line: Simply changing the weight of the outline can better express the pepper's curvature and volume.

Understanding Shape

An easy way to understand the concept of shape is to use a photograph. If you cut out all the objects within the photo (in this case, the flower), you have removed the *positive* shapes. The area that remains after removing the flower is the *negative space,* which creates shapes that are often just as important in developing an interesting and lively drawing. Looking for shapes is the first step in any drawing.

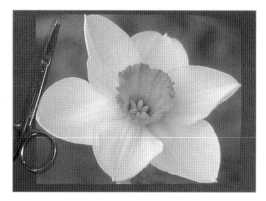

Gathering Materials Use a pair of scissors and a photograph for this shape-finding exercise. It's preferable to start with a photograph of one subject, such as this simple flower.

Pulling Out Positive Space Now cut around the outline of the flower shape and pull apart the pieces a bit so that you can see the shapes clearly. This is a helpful exercise for recognizing both positive and negative shapes.

Deconstructing an Image Carry this concept of space even further by considering that every element of an object is a separate shape and occupies its own space—either negative or positive—including the highlights, shadows, and details.

Seeing Values

Step One Start with a photograph of a simple object, such as this pepper. This way you can make marks on the actual reference, if needed.

Step Two Establish the shape with a contour drawing (as on page 13). Squint your eyes to see the changes from light to dark; then outline each of the shapes you see, refining the drawing.

14

Defining Form

Establishing the form of a drawing subject is one of the most exciting moments for an artist. Form, created through the use of value, moves the drawing from a flat rendering of shapes into a three-dimensional world; with form, your subject seems to rise off the paper, appearing so real that you feel you can almost reach out and touch it.

A

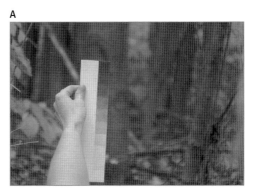

B

▶ **Comparing Values** You can use the value scale below in two ways: (A) Hold it next to the object you are drawing to determine the value of an area, or (B) hold it next to your drawing to make sure that you're creating a matching value. When you hold the scale against your drawing, it will help you see where you may wish to darken or lighten an area to create a more realistic, three-dimensional look.

| 1 | 2 | 3 | 4 | 5 | 6 | 7 | 8 | 9 | 10 |

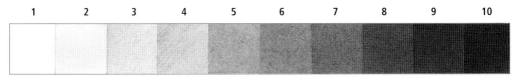

Value Scale Here is a ten-segment value scale, which has a great range for mapping out the values of almost any subject. You'll want to refer to this scale as you draw; it's an important tool for determining values.

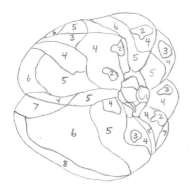

Step Three Now use the value scale shown above to assign a value number to each light or dark shape, as shown. You don't have to use every degree on your chart.

Step Four Finally, use step three as a "map" to shade your object. Don't maintain the crisp outlines; instead, use soft gradations to blend one value shape into the next.

DRAWING WHAT YOU SEE

Most people are accustomed to drawing what they *think* they see, which is simply the *idea* of the object in our minds. Our brains aren't accustomed to recording detailed observations, so we must concentrate on retaining and recalling details for our drawings. Practice drawing what you see.

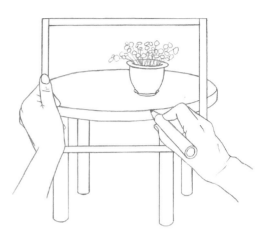

Portable Window Create a portable window from a piece of rigid acrylic, which is available at your local hardware store. Try the same window outline exercise indoors; it will help you understand how to reproduce the challenging angles and curves of your subject.

Window Outline Exercise To train your eye and brain to observe, stand or sit in front of a window and trace the outline of a tree or car onto the glass with an erasable marker. If you move your head, your line will no longer correspond accurately with the subject, so try to keep it still.

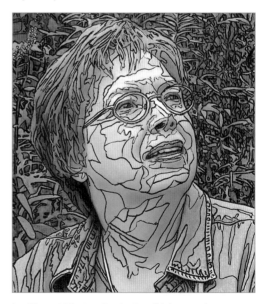

Foreshortening in a Window Drawing
Foreshortening—when an object is angled toward the viewer—causes the closest parts of an object to appear much larger than parts that are farther away. This can be a difficult concept to master, but a window drawing, shown above, simplifies this process.

Looking at Photos Another beneficial way to observe impartially is to find an interesting photo in a magazine. Outline all the shapes and values you see with a pen. Take your time and indicate even the smallest change in value.

Producing Accurate Angles

Now let's take the next step and learn to draw what we see on paper. The more you're able to keep your eye on the subject and let your hand record what you "feel" with your eyes, the more accurate your drawing skills will become. However, you'll find that you can't simply record objects perfectly using only your eyes. It's helpful to have visual references as guides for your lines. You easily can draw a vertical or horizontal line on your paper; this ability seems to come to us naturally, but drawing angled lines does not. However, with practice, you can learn to accurately transfer an angled line to your paper.

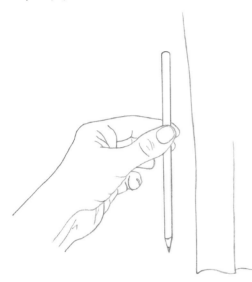

Visualizing Vertical Lines Hold your pencil straight up and down next to your subject. This will help you to see how other lines intersect or veer away from this vertical reference.

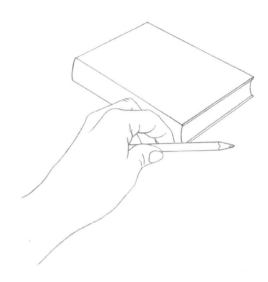

Achieving a Good Bearing You can learn to draw horizontally angled lines in the same way. If you want to be very precise about what is truly horizontal, you can hold the pencil loosely in the middle and let it balance itself. Look from left to right along the pencil to help place your horizontal angle.

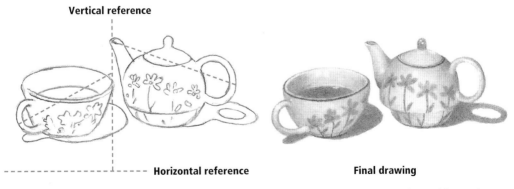

Vertical reference

Horizontal reference

Final drawing

Focusing On Angles Hold your pencil vertically and then horizontally at arm's length in front of your subject. Visually compare the true vertical and horizontal reference "lines" of your pencil to the actual angle of your subject (in this example, the angles from the teacup's handle to the lip on the opposite side, and from the teapot's handle to the tip of the spout). Now you have a good idea of the angle at which you have to place your subjects in your drawing (shown by the dashed lines). Lightly draw the angled lines, using the edges as references. Note that the cup and teapot are angled in opposite directions.

Measuring with a Pencil

Drawing the correct *proportions*—the size relationships between different parts of an object—is easier if you learn to take measurements directly from your subject and then transfer those to your paper. You can measure your subject with just about anything (for example, your thumb). Using a pencil is a very easy and accurate way to take measurements, as shown below.

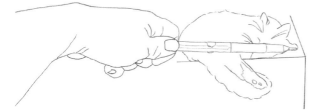

Measuring Width Close one eye and hold out your arm with your pencil positioned horizontally between your fingers, and line up the tip of your pencil with one side of the subject. Move your thumbnail down the pencil until it just touches the opposite side of your subject.

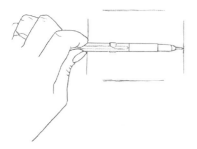

Transferring Measurements Mark the length of your pencil measurements on your paper. If you want to enlarge the subject, multiply each measurement by two or three. If you extend the initial markings to this new measurement, you can form a box around your subject that will work like a grid to help you draw your subject using correct proportions.

Measuring Height Using the same procedure, measure the distance between the highest and lowest points of your subject.

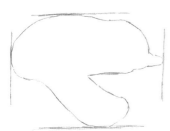

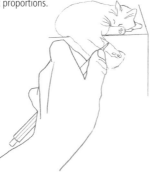

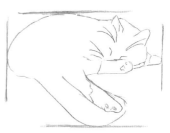

Adding Up the Numbers After you've created the basic rectangle, using the tallest and widest measurements of the subject, sketch the cat's general shape within the rectangle. Keep the shape simple and add details later.

Mapping Out Elements As long as you stay in the same position with your arm extended at full length, you can take additional measurements, such as the cat's foot here, which will be in proportion to the rest of the body.

Correcting Calculations While progressing from a basic shape to a gradually more detailed outline drawing, take measurements before applying any marks to keep your drawing in proportion.

Drawing with a Grid

Another effective way to learn how to draw what you see is the grid method. The viewing grid shown below is an open, framelike device divided with string into several sections of the same size. This tool helps you break down the scene into small, manageable parts, giving you clues as to where your subject should be placed on the paper. A grid stand will hold it steady and in the same place for you.

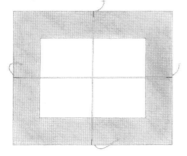

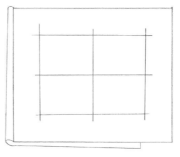

Step One Cut a rectangle out of the center of a piece of cardboard. Find the exact center of all four sides of the outer rectangle and make a small cut on the outside border. Slip two pieces of string through the slits—one horizontally and one vertically—to divide your viewing grid into four equal sections.

Step Two Use a ruler and a pencil to lightly draw the same size grid (or a proportionally larger or smaller one) with the same number of squares on a piece of drawing paper. To draw a larger or smaller grid, multiply or divide each measurement by the same number, usually two or three.

Step Three Hold the cardboard grid at arm's length and use it to frame the scene or object you want to draw. You must keep the grid and your head in the same position for the duration of the drawing, so make yourself comfortable from the start.

Step Four With one eye closed, observe your subject through the grid and notice at what points its outlines cross the grid lines. Then carefully transfer these points to the grid on your drawing paper.

Step Five Now that you've plotted these important reference points, you can begin to fill in the lines between the points. Draw one section at a time, looking through your grid and noting where the shape fits within the grid lines.

Step Six Keep drawing, square by square, frequently studying the subject through the grid until the drawing is complete. Then erase the grid lines, and you will have an accurate line drawing of your subject.

SHADING TECHNIQUES

As we discussed on page 15, value is essential in suggesting the form, or three-dimensional quality, of a subject. There are many ways to apply and manipulate graphite on your paper to create a range of values, but *how* you apply the graphite is what determines the texture of the subject. Explore the techniques on the following pages so that you can learn a variety of shading styles and pair the appropriate technique with a subject.

Hatching and Crosshatching

The most direct way to lay down a layer of graphite to create a darker value is by simple *hatching,* which is a series of parallel strokes. If you squint your eyes and look at a hatched area, the lines seem to mix together to form a value that is darker than the paper yet lighter than the actual lines of graphite. The closer you place the parallel strokes, the darker the value.

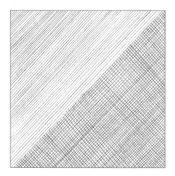

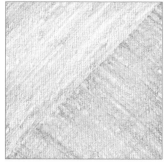

Overlapping Lines A simple way to create a darker value using hatching (upper left) is by adding the same pattern of lines perpendicular to the first layer of hatching (lower right). This is called "crosshatching." Cross-hatching is a quick, all-purpose way to add value and texture to a drawing.

Using the Side of the Pencil Create a softer look by hatching with the side of your pencil (upper left). Again, you can darken an area more by cross-hatching over it (lower right). This type of hatching might be a good choice if you are drawing a lightly textured cloth or a field of weeds.

Varying Values This example shows the difference between "loose" hatching and "tight" hatching. Loose hatching, with the lines spread far apart (upper left), is best for areas of light value; the tighter, or closer, the hatch strokes, the darker the area will be (lower right).

Making Scribbles If you make an even, but rough-textured, scribble hatch (upper left) and then crosshatch (lower right), you can create a seamlike quality that might be used to draw loosely woven fabric, mesh, or basketry.

Combining Methods You can create hatching with any type of line. I made this hatch and crosshatch with a loose, uneven scribble movement. It yields an interesting texture that would be perfect for rendering distant foliage.

Applying Smooth Hatching

Although hatching with bold, rough strokes is great for quickly identifying areas of shading in a sketch, applying finely hatched lines yields a more finished look. This technique is called "smooth hatching." Smooth hatching takes a bit of practice to master, but it is essential for creating gradations that suggest evenness of texture, curvature, and form. Like so much of drawing, your ability to make a smooth hatch will improve as you gain more control over your tools. Follow the exercises below to practice the subtlety of pencil pressure associated with smooth hatching.

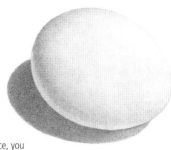

Mastering Smooth Hatching After some practice, you will be able to create a tight hatch that needs no further smoothing or blending with stumps or brushes, as demonstrated with this egg.

Exercise One Using medium pressure, draw a square and divide it in half diagonally. In the lower right corner, use a sharp B lead and minimal pressure to create a light hatch. Then create a dark hatch in the opposite corner using heavier pressure. Continue hatching from the dark area toward the centerline, using increasingly less pressure as you reach the middle. Develop the gradation even more by filling in areas between the hatch marks.

Exercise Two Now execute a similar smooth hatching, this time concentrating on extending the darker value past the diagonal halfway mark. For this exercise, experiment with a softer grade of pencil to suit the darker value. For example, try a 4B within the dark half and gradate to a B for the lighter side. The more you stroke over the sample (avoiding heavy pressure that may damage the paper's surface), the smoother the hatch will become.

Hatching for Form

Curved hatching that follows the subject's form emphasizes curvature, making it seem as though you could grab the object off the paper. Even when two drawings are shaded similarly, a drawing that makes use of curved hatching will appear to have more form than a drawing that uses straight hatching. A good example of this involves the two gourds shown below.

Hatching with Straight and Curved Lines I shaded the gourd on the left using straight hatching and crosshatching over the shape, without regard to the lines of the gourd's contours. The gourd on the right employs hatch lines that follow the curvature of the subject's form, resulting in a greater sense of depth.

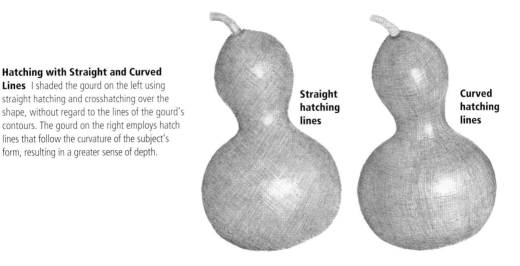

Straight hatching lines

Curved hatching lines

Understanding the Properties of Pencils

Two important factors to consider when creating a value with graphite are the degree of hardness of the pencil and the sharpness of the tip. It's much easier to create a dark value with a soft pencil than with a hard one, and the softer pencil will leave a rougher-looking texture when stroked over the grain of the paper. The diverse looks created by different grades of lead can be used to mimic textures of objects in your drawings. Also try creating samples with both sharpened and dull pencil points; you'll see that the sharper the pencil, the darker your value will be, even when you're using the same amount of pressure.

Using Sharp and Dull Points
Sharpen a B pencil to a very fine point and fill a box using medium pressure (above left). As your pencil dulls, create another box using the same pressure (above right). You will see that the sharpness of the lead creates different values and textures. I used a 2B pencil for the bottom row, also using sharp, then dull, points.

Effecting Value Through Grade Each of these graduated samples is made with a different grade of lead (from left to right): 4H, 2H, B, 2B, and 4B.

Changing Grades to Achieve a Dark Value

Although it's easier to create a dark value with a soft lead than with a hard lead, you'll find that the soft lead actually skips over parts of the paper, leaving behind little white spots that dilute the value. It's tempting to just press harder with the pencil to achieve a dark value, but this only flattens the grain of the paper, creating an especially shiny and distracting spot on your drawing. To create a very dark value without flattening the grain of your paper, first go over the area several times with a very sharp, soft lead, using light to medium pressure. Follow this with a slightly harder, sharp lead. The harder lead pushes the previously applied, softer graphite into the grain of the paper that was skipped over before, so the entire area is coated—there won't be any white areas or shiny spots.

Layering First shade with a soft lead (7B). Then use a slightly harder lead (4B) to go over the top half using the same pressure. Compare the two areas and notice the effect of the hard lead on the value.

Hard over Soft
In this example, I applied 7B first in the top two thirds, followed by 2H in the bottom two thirds. The center area of overlap shows how hard lead applied over soft lead darkens the value.

Soft over Hard
Here I applied 2H first in the bottom two thirds, followed by 7B in the top two thirds. The center area of overlap shows how soft lead doesn't stick on surfaces coated with hard lead.

Applying Graphite Powder

You don't need a pencil to create value—you can apply graphite powder (see page 7) with anything that doesn't damage the delicate surface of the paper. To create a range of effects, try different household items, such as cotton swabs and scraps of cloth. Don't use your fingers to smooth the graphite, as skin oils bind with the graphite, making a slick area that repels additional graphite and cannot be erased well.

Blending with a Brush Create a smooth, cloudlike effect by applying loose graphite with a brush.

Using a Blending Stump You can create soft lines and subtle graduations using a blending stump dipped in graphite.

Smudging with Tissue Paper Thin, smooth tissue paper gives a muted, gritty effect when used to apply graphite.

Pencil over Powder Quickly cover large areas by laying soft lead pencil strokes over brushed graphite. The brush doesn't affect the paper's grain, so soft lead can be applied over the powder.

Powder over Pencil To darken smaller areas with precision, hatch with a soft, sharp lead. Then apply graphite with a brush, pushing and rubbing the graphite to cover the white areas of the paper.

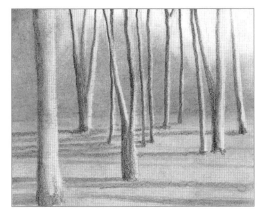

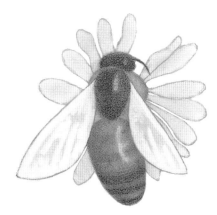

Drawing with Erasers Shade shapes like these trees all over with graphite dust; then drag your eraser along the drawing to reveal the underlying paper. I use this method to highlight branches and tree trunks, showing the way the light hits them.

Creating Special Effects To form delicate light areas, such as an insect's wings, first fill in the area with a light, uniform application of graphite dust; then lift out light tones with a kneaded eraser. Leave some dark values as accents or shadows.

DECIDING WHAT TO DRAW

Excellent subjects for drawing are all around you right now, but you may not recognize them as such. My advice, as you begin your search for things or people to draw, is to find subjects you love. After all, you'll be spending some very special time with the subject as you draw, so it should be something you truly enjoy! Consider using your children, other family members, pets, collections, or the garden as possible sources for drawing inspiration.

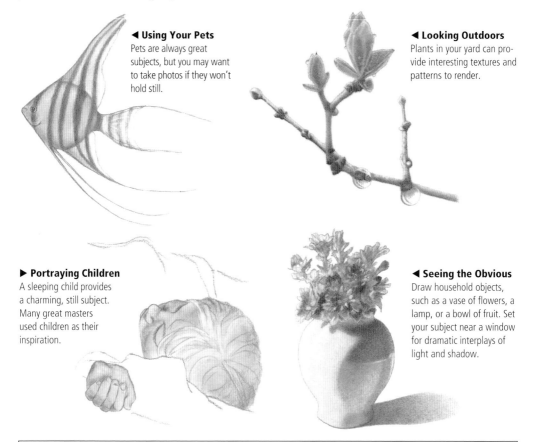

◄ Using Your Pets
Pets are always great subjects, but you may want to take photos if they won't hold still.

◄ Looking Outdoors
Plants in your yard can provide interesting textures and patterns to render.

► Portraying Children
A sleeping child provides a charming, still subject. Many great masters used children as their inspiration.

◄ Seeing the Obvious
Draw household objects, such as a vase of flowers, a lamp, or a bowl of fruit. Set your subject near a window for dramatic interplays of light and shadow.

Selecting Paper for the Subject

Another choice for you to make, as you consider the subject of your drawing, is the texture of your paper. It's a good idea to test the paper to see if you can re-create the textures of the subject on that surface. For example, it's more difficult to render fine details on rough paper than on smooth paper. But rough-textured paper can be perfect for depicting coarse surfaces, such as tree bark or bricks.

Seeing the Difference Notice how the smooth paper (left) communicates the slick, shiny quality of the grapes better than the rough paper (right).

Finding Interesting Elements

As you begin narrowing down your choices, determine the aspects of a subject that appeal to you. Try to view the object without regard for color; instead, look for lighting, textures, forms, lines, and angles that often are overpowered by color. Dynamic lighting is something you easily can develop an eye for, as it provides pleasing contrasts and creates shapes that wouldn't exist in normal light. Another quality to look for in a potential drawing subject is interesting texture, which is often heightened by the way light strikes its surface. Form is another aspect to become more sensitive to as you select drawing subjects. The form of even an ordinary object can be exquisite if you experiment with your viewpoint, looking at it from different angles. Try looking at flowers, trees, and even people at unusual angles, such as from a very low or very high viewpoint.

Investigating Textures The degree to which an object appears rough or smooth, soft or hard, depends not only on its actual texture, but on the way the light strikes its surface.

Considering Light Beautiful lighting is easy to appreciate. Study some highly praised photos from the 1930s and 1940s, when color wasn't available, and you will begin to notice how light accents different forms.

Rearranging Views Try looking at a flower from a different angle rather than peering down at it. Come nose to nose with it, and you will be delighted with the interesting shapes and lines you'll discover.

Looking for Linear Beauty Lines move in many directions. They can guide the viewer's eye and create drama.

WORKING FROM LIFE OR PHOTOS

Whether you choose to draw from life or from photos is entirely up to you. Drawing from photos is clearly more convenient, but you'll find plenty of advantages to being "on the spot" during your artistic process. Use the method that works best for your style—or combine both!

Participating in Life Drawing

Drawing the scene you see right in front of you can present a wonderfully fresh opportunity. All of your senses are involved, so your response to the scene is unlike that of anyone else—even if they were to sit in the exact same spot. Furthermore, your emotional response to your surroundings will affect the quality of the design elements that you attribute to the subject, projecting your feelings onto the page!

Engaging in Visual Meditation

"Visual meditation" is a great way to gain a visual understanding of your subject before drawing. Instead of immediately touching the pencil to paper, first ask questions that help you focus on the visual qualities:

Where are the darkest and lightest areas?
Where are the widest and tallest parts?
What different line qualities appear?
What direction is the light coming from?
What parts are lighter or darker than the background?
Does any part of it look hard or soft?
What positive and negative shapes appear?

▲ **Recording Details** Drawing from life allows you to become totally immersed in the scene. You become aware of everything around you, and you have emotional responses that influence your decisions about value, shape, line, and viewpoint.

◄ **Evoking a Memory**
Viewing a simple line drawing of a weed can bring back sensual and emotional memories: the smell, temperature, and breeze you experienced while drawing, as well as your thoughts and feelings.

Capturing a Season An autumn scene with dark, brooding clouds and dramatic lighting makes a good subject for visual meditation and drawing.

Referencing Photographs

Photographs are valuable reference tools that most artists use. Some challenging subjects are easier to draw from photos. It's also possible to pull out usable visual information even from poorly shot photos. I photographed beautiful trees with round leaves that looked like flashing silver mirrors dancing in the wind. My camera failed to record this exact phenomenon of light, but I *was* able to determine the direction of light, tree branch formation, shadows, and the texture of the weeds surrounding the tree trunks.

◀ **Towering Timber** The bright reflections from a stand of aspen trees that caught my eye are barely visible in this photograph.

▶ **Extracting Information** Rather than discarding the photo, I studied it carefully and created a sketch of the aspen trees in the center.

Exploring Outdoor Subjects

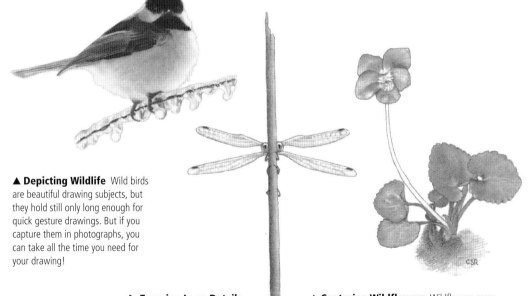

▲ **Depicting Wildlife** Wild birds are beautiful drawing subjects, but they hold still only long enough for quick gesture drawings. But if you capture them in photographs, you can take all the time you need for your drawing!

▶ **Zooming In on Details** Become a paparazzo of the bug world—use your close-up lens to capture even the smallest details, such as this dragonfly on a branch.

▲ **Capturing Wildflowers** Wildflowers grow close to the ground in boggy areas. Photograph these subjects, and take your references home to draw in comfort. Remember to record notes about fine details and values in a sketchbook to supplement your photos.

Taking Artistic License with Photos

A surprising discovery that you might make while drawing from photos is that some colors, such as red and green, have the same value. When you view these colors together in black-and-white, they merge into each other and lose the valuable contrasts that help define the forms. The solution to this problem is to adjust your drawing to better portray what your eyes see. This is called taking "artistic license." You may choose to draw one of the colors lighter or darker than it really is, interpreting the color contrasts you see in life with an artistic eye.

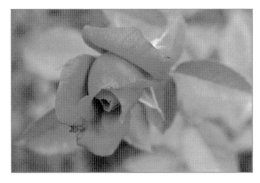

▲ **Examining Similarities** Your eye would have no trouble distinguishing the red rose from its surrounding green leaves when viewed in color. However, in a grayscale photo (above), notice that the rose and its leaves share the same intensity of value.

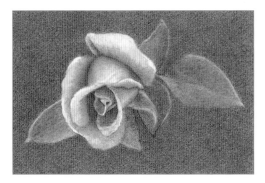

▲ **Manipulating Values**
Because the leaves and rose have similar values, I compensate by lightening the flower and darkening the leaves (above).

▶ **Retraining Your Eye**
Your artistic eye can isolate the flower in this busy scene, but the camera sees all (near right). As you develop your drawing, you may choose not to render the background, but rather create an engaging contrast (see drawing at far right).

Taking Multiple Photos

I recommend that you take plenty of photos using different focal points and angles. Having several slightly different reference photos of the same subject gives you a wide selection of arrangements.

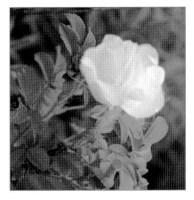

Zooming In Capturing the delicate curves of the petals, a close-up of a wild rose is a beautiful reference for drawing.

Zooming Out This photo includes more of the interestingly shaped leaves, providing less detail but more textural contrasts.

Combining Multiple Photo References

You easily can take elements from separate photographs and piece together a *composition* (the arrangement of elements on your paper), as I did for the drawing below. In photo 1, the chicks peek out from under their mother's wings, but the broom is out of focus and cut off. I photographed the broom separately (photo 2) and compiled elements from both photos to make one drawing.

Photo 1

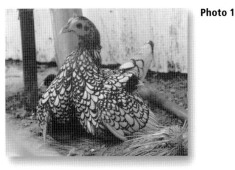

"Alice on the Broom"
I combined elements from photos 1 and 2 and eliminated the background for this drawing.

Photo 2

29

USING YOUR COMPUTER

A computer with image-editing software, a scanner, and a printer can simplify the process of planning a composition and can help you recognize a range of values. Most image-editing programs can improve your photos or simply tailor them to emphasize the elements you choose. Start by converting your image to gray scale, so you can see the values without the distraction of color. Then resize your image to a suitable reference size. Next print out the reference or adjust the image for a better composition.

Cropping Photos

Using the cropping feature in your image program will allow you to adjust the photo to determine the best composition. Try cropping out distracting elements or zooming in on your focal point. Create several options onscreen and choose the one that works best.

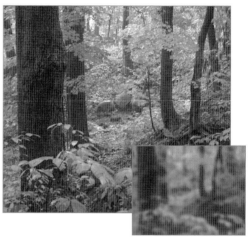

▲ **Seeing Value** After converting your reference image to gray scale, use your computer to create a blurred version of the image. This will help you see the underlying values. If you apply these values first to your drawing surface and then add details, your drawing will appear beautifully rendered and realistic.

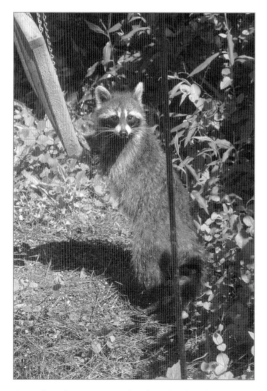

Cropping Photos Start with a photo that has plenty of extra space around the subject. Then frame various compositions within the photo by experimenting with cropping.

▲ **Experimenting with Shaped Images** Your imaging program should allow you to crop your image to different shapes, such as the oval above.

◄ **Finding Detail** With digital photos, you usually can zoom in and take a closer look at the fine detail of your subject. This can help you render the textures and depict accurate highlights.

Improving Light and Contrast

Adjust the lighting of your reference photos using the brightness and contrast options of your image-editing program. You can lighten or darken a picture, as well as intensify or diminish the contrast. These features can turn dark, muddy, or washed-out photographs into ideal references.

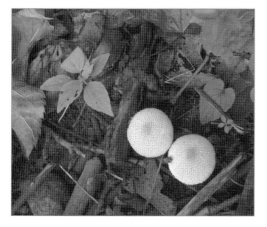

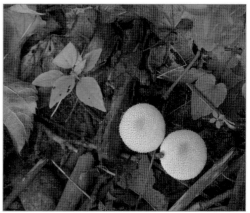

Before Adjusting In this photo, the area around the two mushrooms is made up of objects of similar values, giving the picture a washed-out look.

After Adjusting Slightly increasing the contrast brings out a greater range of values. The darker shadows and more defined highlights create interesting shapes and diagonals that weren't apparent previously.

Combining Images

Instead of mentally merging two images (as shown on page 29), you can use an image-editing program to physically piece together separate photographs. For example, you can take an interesting tree or building from one image and place it in another scene. Work with each image as a separate layer in your image document, so you can manipulate the image on each layer individually or move one image over the background to compose your reference.

Photo 1 The values of the sky are perfectly captured here, but the hayfield is too dark.

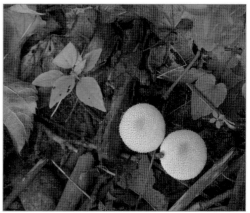

Photo 2 This photo shows the correct values of the hayfield, but the sky is completely washed out.

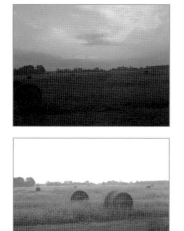

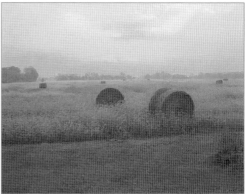

Combined Image I cropped the sky from the photo 1 and merged it with the hayfield from photo 2. The combination of these two elements works well, even though the two individual photos had weaknesses.

LIGHT AND SHADOW BASICS

Light and shadow are key to shaping the contrasting values that create form. Through close observation and manipulation, you will learn how the control of light and shadow within your references can produce a variety of effects and moods in your drawings.

Understanding the Light Source

The qualities of light and shadow vary in all parts of a country and all over the world. All means of illumination—including the sun, the moon, a lightbulb, a candle flame, or a roaring fire—result in cast shadows. Natural lighting changes as the sun arcs overhead. The sequence of photos below show how shadows and highlights move and change throughout the day. Notice how these changes affect the subject, and try to determine the direction of the light source through your observations.

Early morning sun

Mid-morning sun

Noon sun

Mid-afternoon sun

Late evening sun

Manipulating the Light Source

You have a degree of control over the light source, whether it is natural or artificial. Manipulating the lighting allows you to achieve the desired value range. Try photographing an object using various light sources and assess the effects, as I have done with the stemmed dish below. Direct lighting can produce dramatic results, highlighting the textures and creating interesting shapes, whereas filtered lighting may give the object a limited range of values.

◀ Using Pure Sunlight
Direct sunlight from the side and slightly behind can be harsh, but it also can produce bright highlights and intensely dark shadows.

▶ Filtering Natural Light
Sunlight coming through a sheer window curtain is often bright, but soft and without harsh contrasts, for a limited value range.

◀ Lighting from a Distance Light from a distant fireplace or lamp can be very dynamic. Edges farthest from the light contrast with the sharp line of the lighted edge.

▶ Lighting Close Up
Candlelight can produce either bright highlights or a subdued, blanket of light, depending on its position.

Lighting for Emotion

The position and intensity of the light source can elicit an emotional response from the viewer. *Back lighting*—when a subject is lit from behind—provides a soft, radiant glow and often is associated with memories and nostalgia. Low intensity lighting is calming, whereas bright, overall lighting conveys energy. And strong lighting creates drama by forming intense contrasts.

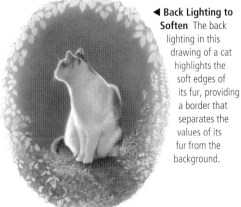

◀ Back Lighting to Soften The back lighting in this drawing of a cat highlights the soft edges of its fur, providing a border that separates the values of its fur from the background.

▲ Setting the Mood Low lighting in a dark scene can be soothing and calming. This type of lighting suppresses details, and our eyes focus on the soft, light shapes in the drawing.

COMPOSITION BASICS

To a large degree, the composition of your drawing (see page 29) is a matter of personal taste. You have the artistic license to leave out, add to, or rearrange the elements in any way you think would make it a better drawing. However, some arrangements of elements are more effective than others when it comes to making a piece of art look balanced and interesting to the eye. The basic guidelines on these pages will help you in your quest for creating a dynamic composition.

Placing Subjects

Most beginners place the primary subject in the very center of their drawing. Central placement looks very balanced and generally is pleasing to the eye, but your eye will remain in the center, rather than move around to the various shapes and planes within your drawing. If the subject is placed slightly off center, your eye is more likely to follow a path through the drawing, taking in all the elements. Avoid intersecting corners with lines, as this leads the viewer's eye out of the drawing.

Centering the Subject Placing the subject in the center creates symmetry, but it is predictable, dull, and stagnant.

Placing the Subject Off Center Positioning the subject off center creates more intriguing positive and negative shapes.

Leading the Eye Outward Prominent lines intersecting the corners of the drawing (as shown above) will distract the viewer's eye from the focal point.

Pulling In the Eye Moving lines and edges away from corners will guide the viewer's eye back to the center of interest.

Symmetry vs. Asymmetry

Symmetrical designs, which involve similar shapes and weight on both sides of the drawing, give a feeling of balance, steadiness, and harmony. But too much symmetry in a composition can be boring. Try including some asymmetry in your designs. Asymmetrical (or unbalanced) compositions give the feeling of anticipation, motion, and liveliness, and tend to guide the viewer's eye around the entire scene.

Symmetrical Placement In this example, there is roughly the same amount of dark values on either side of the leaves, making it symmetrical. Also, the two center leaves are about the same size, which adds to the symmetry.

Asymmetrical Placement Here the leaves are of varying shapes and begin at the upper right corner of the composition, creating asymmetry and making the scene more interesting. The curve of the leaf arrangement around the corner moves the eye to all parts of the drawing.

Framing Your Compositions

The edges of your drawing frame your subject and can definitely impact your composition. In general, a rectangular shape is considered more visually interesting than a square edge. Eliminating sharp corners softens the image and focuses the viewer's eye, as seen in the examples below.

◀ **Full, Rounded Shapes** Circles and ovals give your drawings a bubbly, youthful, and whimsical quality—perfect for illustrating children's books, fantasy artwork, and drawings of children.

▶ **Softened Edges** Rounding the corners of a rectangular frame softens the shape. Irregular edges are perfect for natural subjects, like this bird.

▲ **Ovals for Nostalgia** The soft, vertical, oval shape of this drawing adds a wispy, nostalgic feeling. This subject reminds me of the way my mother would place a bottle with fresh flowers on my windowsill.

PERSPECTIVE BASICS

Perspective is the representation of objects on a two-dimensional surface that creates the illusion of three-dimensional depth and distance. By applying the rules of perspective, artists are able to convey a sense of space in their drawings, making them appear more natural, realistic, and engaging.

One-Point Perspective

One-point perspective suggests that all receding lines meet or vanish at one spot—called the "vanishing point" (VP)—on the *horizon line* (the imaginary line that represents the viewer's eye level or the actual horizon). A good example of one-point perspective is a railroad track that seems to converge and disappear as it recedes into the distance.

Two-Point Perspective

Objects that are viewed from an angle have more than one plane, and must conform to the rules of *two-point perspective,* where there are two or more vanishing points. On your paper, draw a horizontal line for the horizon, and mark a point at each end of the line for your two vanishing points. Follow the steps below to draw a three-dimensional box.

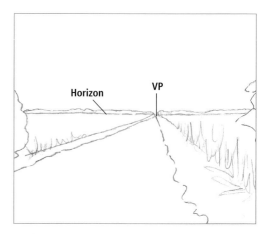

Applying One-Point Perspective Country roads and railroad tracks engage viewers, pulling them into the composition. Use the rules of perspective to represent them in a realistic way. In this example, the vanishing point is labeled "VP"; all lines along the road recede to this point on the horizon.

Drawing a Box in Two-Point Perspective

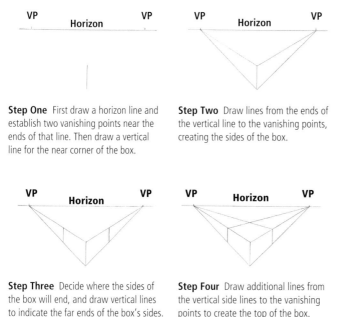

Step One First draw a horizon line and establish two vanishing points near the ends of that line. Then draw a vertical line for the near corner of the box.

Step Two Draw lines from the ends of the vertical line to the vanishing points, creating the sides of the box.

Step Three Decide where the sides of the box will end, and draw vertical lines to indicate the far ends of the box's sides.

Step Four Draw additional lines from the vertical side lines to the vanishing points to create the top of the box.

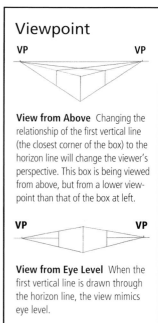

Viewpoint

View from Above Changing the relationship of the first vertical line (the closest corner of the box) to the horizon line will change the viewer's perspective. This box is being viewed from above, but from a lower viewpoint than that of the box at left.

View from Eye Level When the first vertical line is drawn through the horizon line, the view mimics eye level.

Achieving Atmospheric Perspective

Another way to give the impression of depth is to apply *atmospheric perspective,* which shows the loss of contrast, detail, and sharp focus that occurs when particles and humidity in the air filter our view. When you are outdoors viewing a scene, you will see that colors change as objects recede into the distance. Bright whites and velvety blacks tend to wash out and eventually disappear into a smoky, nondescript background. Fog, rain, smoke, or snow will intensify atmospheric perspective, adding a dramatic touch to your drawings.

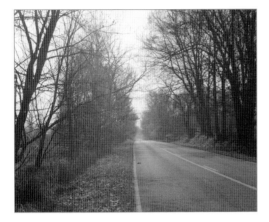

Revealing Depth This photo of a receding road is the perfect demonstration of atmospheric perspective. As your eyes move down the road, you can see how the limbs and twigs of the trees become less discernible.

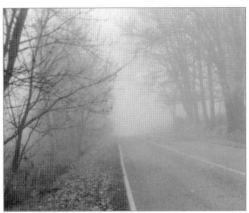

Enhancing Atmospheric Perspective Foggy conditions can increase the effect of atmospheric perspective by blurring the trees and increasing the contrast in value between the foreground and distant branches. It can even make objects in the distance disappear completely. Note the differences between the photo above and the one at left with the fog.

Establishing Realism Atmospheric perspective adds reality and depth to any outdoor scene. Here I saved the sharpest detail for the wheat in the foreground, while keeping the more distant wheat less distinct and lighter in value. Although the trees by the barn have less detail than those in the foreground, they are still much more discernible than the distant trees, which have been reduced to mere suggestions.

TEXTURE BASICS

Texture can be broken down into patterns of light and shadow, making the texture easier to reproduce on paper. When I draw a large textured area, I always use the same sequence of actions: hatch and blend the middle value of each area; hatch and blend the large shadow areas; pull out the large highlighted areas with an eraser; draw in the small and dark details; and use an eraser to pull out the smallest, lightest details. This step-by-step exercise will help you focus on replicating the soft fur of a teddy bear. You'll need 2B, B, and 2H pencils; a kneaded eraser; and small and large trimmed brushes for this project.

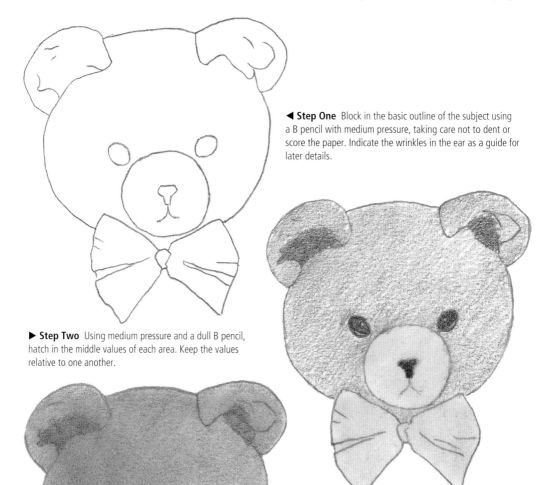

◄ **Step One** Block in the basic outline of the subject using a B pencil with medium pressure, taking care not to dent or score the paper. Indicate the wrinkles in the ear as a guide for later details.

▶ **Step Two** Using medium pressure and a dull B pencil, hatch in the middle values of each area. Keep the values relative to one another.

◄ **Step Three** Stroke over the entire drawing and smooth it using different sized brushes. Use the small brush for little areas that require cleaner edges, and use the large brush, which doesn't require as much control of the bristles, for bigger areas.

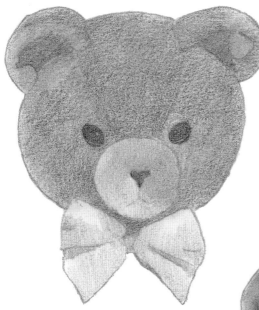

◀ **Step Four** Hatch in the large facial shadows to a value of 6 (see page 15) with a dull B pencil. Look only at the overall shadow shapes and exclude the darkest details. Perform the same process on the muzzle and bow, using a 2H pencil and very light pressure.

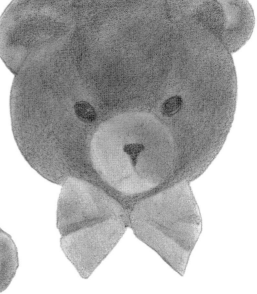

▶ **Step Five** Smooth the hatching again with a brush, blending just enough to produce a soft and fuzzy appearance, and allowing the slightly rough paper to do some of the work. Work the same way on the bow and muzzle, using very slight pressure on the brush.

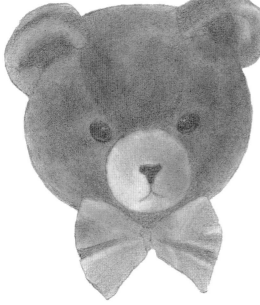

◀ **Step Six** Shape your kneaded eraser to a rounded point to lift out highlights. If you lighten an area too much, re-darken it by rubbing the brush back and forth over the highlight.

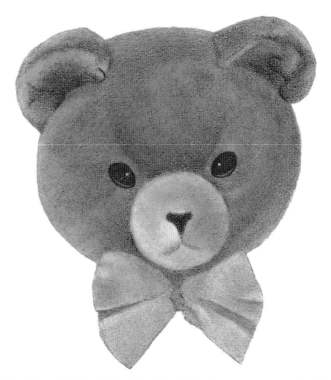

Step Seven Use a sharp 2B pencil to draw dark details, including the bear's eyes, nose, ears, and muzzle. Switch to a sharp B pencil to create the dark details on the muzzle and bow. To achieve these dark values, stroke over the soft areas with a sharp, hard pencil (see page 22). To finish, I carefully lighten the highlights under and in the eyes with a kneaded eraser pinched into a fine point.

Depicting Hard, Rough Textures

The world is full of fascinating textures, and you can replicate them all in pencil. As you've learned in this step-by-step lesson, the teddy bear's soft plush fur requires considerable blending and soft edges. However, the tree bark texture examples at right require more contrast in value and sharper lines. Experiment with your textural capabilities by attempting to re-create these rough textures.

Ash Tree Bark Create the rough texture of this tree by drawing ragged ridges with dark, coarse strokes against a medium background.

Cherry Tree Bark Although this bark is much smoother and shows less contrast, the hard nature of the trunk is maintained by the crisp, defined edges.

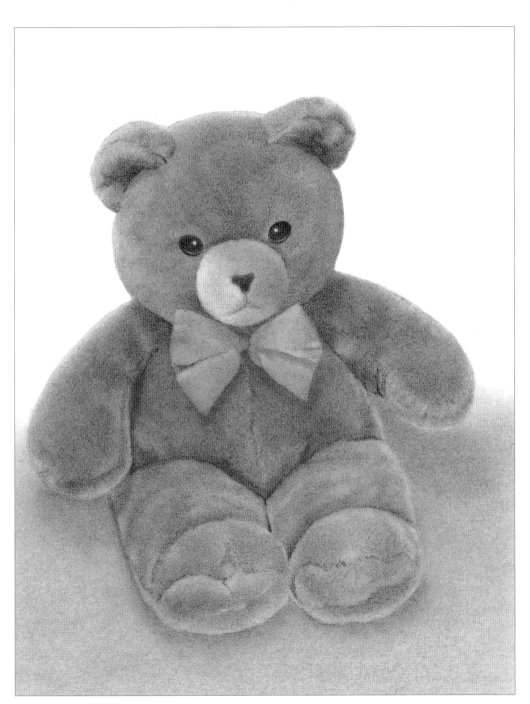

Step Eight Draw the rest of the plush body in the same manner as the head, starting with an outline and building up the values and textures in layers. The texture of the paper contributes to the plush look of this teddy bear. I chose cold-press watercolor paper with a slightly rough texture because the recessed areas of the paper catch the graphite, creating a pattern that mimics the soft, furry quality of the bear's plush material.

RENDERING DETAIL

Some people choose not to include many details in their drawings, preferring to deal mainly with abstract shapes and modeling; in that case, they need to depict only the most essential details. But other artists thrive on detail and delight in carefully re-creating everything exactly as they see it. Most people actually fall somewhere in between—they might want to add some detail, but they don't want to spend the time and effort rendering every crease of their subject. No matter your preference, it's important to cultivate a sense of which details of a subject are the most essential.

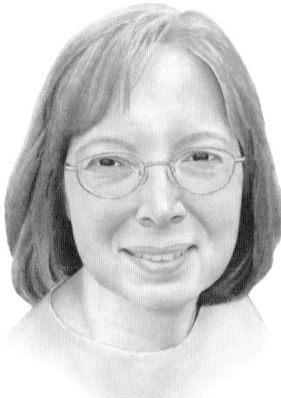

▲ **Eliminating Extra Work** It's not important to capture every detail when drawing hair. The hair seen here (from the drawing at left) consists of masses of light and shadow, with only hints of detail.

▲ **Detailing Portraits** Details are extremely important in the eyes, nose, and mouth. Other items, such as clothing and hair, can be merely hinted at with soft variations of value, guiding the viewer's eye to the focal point—the face.

▶ **Considering Size** The drawing at right is shown at 82% of its actual size. Note the amount of detail I've included. Miniature drawings need a fair amount of detail to accurately represent the objects in a small space, whereas large drawings have plenty of room to establish a good sense of an image and often may require less detail per square inch.

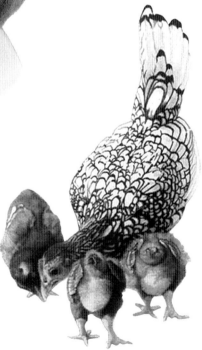

▶ **Far Away** This mum is meant to be viewed from a distance of six to eight feet—the typical viewing distance for most artwork. I apply the detail accordingly, leaving out any fine lines and highlights that wouldn't be visible from this distance.

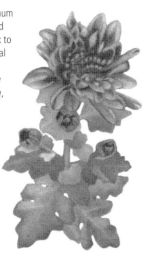

▶ **Close Up** This mum has much more detail and can be enjoyed at a very close distance to the viewer. However, keep in mind that this mum will look nearly the same as the one at left if seen from the average viewing distance (six to eight feet).

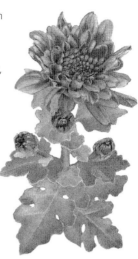

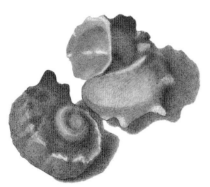

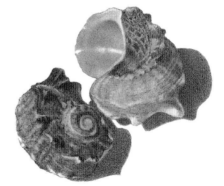

Moderately Detailed The details of close-up compositions, like these shells, often are the focus of the scene, so add as many details as you feel comfortable drawing.

Highly Detailed If adding intense detail, as shown in the shells above, appeals to you, go for it! Note the intricate details that are possible to replicate with pencils.

Interpreting Detail from Photos

Photographs allow us to record the details of a scene that we wouldn't normally perceive with our own eyes. However, you don't want to painstakingly reproduce every detail— instead, choose one or two aspects of the image that you would like to focus on and re-create them.

Photographic Detail This photo captures the tree's every leaf, ridge, and value.

Step One Start drawing by building the foundation, paying attention only to shape and value.

Step Two Focus on suggesting the dappled leaf pattern, pulling out graphite with a kneaded eraser.

PROJECT 1: LANDSCAPE

To create this dramatic landscape scene, I used two photographic references: one that captures an interesting sky and one that presents a pleasing foreground. When I merge these elements, I achieve a better composition with a soft feel and subtle gradations in value. To best depict these qualities, I choose smooth paper without much texture.

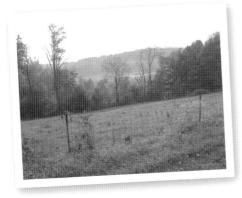

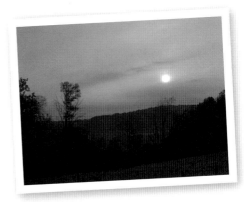

Capturing Contrasts I took this photo near Shavehead Lake in Michigan. It includes a range of values, textures, and lines—from the detailed foreground to the distant hill.

Pulling Out the Sky In this photo, taken from the same spot, I captured the drama of the sun veiled by sheets of soft clouds. I combined this photo and the one at left for my drawing.

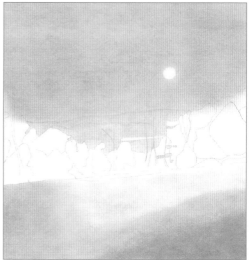

Step One Measure and frame the scene, roughing in a few details. Designate certain prominent trees to serve as reference points and also add the most obvious dark tree trunks. Then delineate the trees, meadow, and sky according to the differences in value. Once this "map" is in place, assign a number value to each section, using the value scale on page 15 as a reference.

Step Two Mask the edges with tape to keep them clean and neat. Using loose graphite and a short, wide brush, fill in the entire sky area to a #4 value. Brush the graphite down over the skyline and into the treetops, and smooth the sky with a tissue, avoiding the sun. Do the same for the meadow, working from a value #5 in the bottom right and gradating to lighter values.

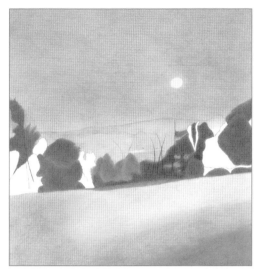

◀ **Step Three** Fill in the light- and middle-value trees using smooth hatching made with medium-soft pencils. Brush over the hatching after each layer to help even out the tone, repeating this process until each tree reaches the desired value. Then lightly rub the tree shapes with a tissue wrapped around your finger for an extra smooth texture.

▼ **Step Four** Using smooth hatching (see page 21), fill in the darker tree shapes and smooth each area with a brush. Where two or more trees touch, darken one edge to push it back. Next brush loose graphite over the darkest parts of the drawing, repeating until you achieve the darkest value your paper allows.

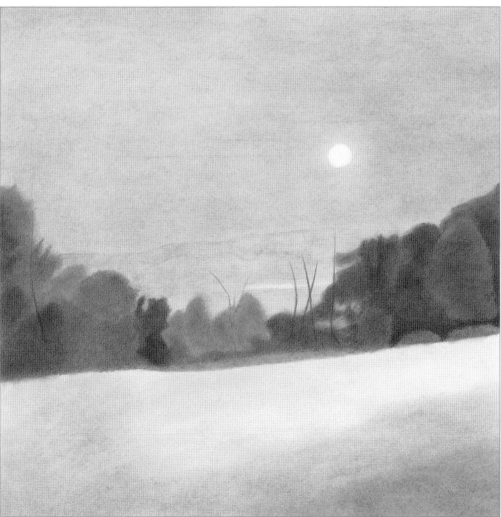

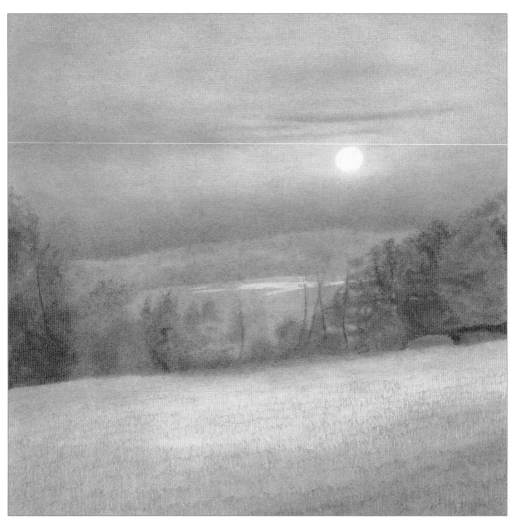

Step Five Apply loose graphite with a brush, using horizontal strokes to darken the sky, and smooth out the graphite by sweeping a tissue in a horizontal motion over the entire area. Then darken the distant trees and swamp area to a #5 value using a hard lead and horizontal hatching, taking care to leave the tops of some of the tree clumps lighter for easy identification in the next step. Darken the sky above the hills with a hard pencil to help separate the tree line from the sky. Using the point of a stick eraser, shape and lift out the water visible in the swamp area. Then pinch a kneaded eraser to a point and use it to lift out all the highlight areas of the middle-ground trees. Prepare the base for the grass texture in the foreground meadow by applying rough vertical hatching with a medium-soft pencil.

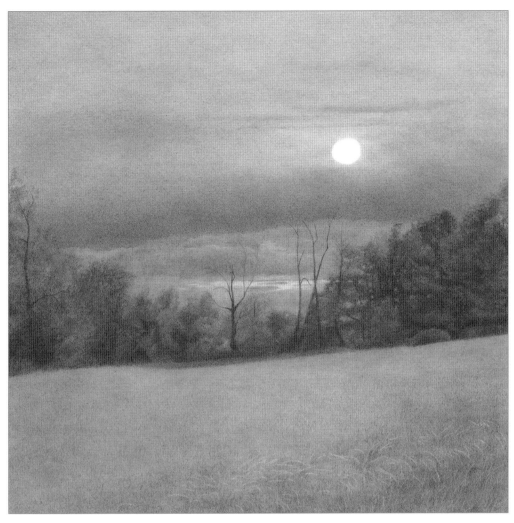

Step Six Mottle the clouds using very hard pencils and a clean blending stump, and then complete the sun (see "Brightening the Sun" below). To further define the treetops, redraw the skyline with a series of scalloped strokes; then darken the branches and twigs (see "Creating Twigs" below). Soften the meadow by blending the hatching from step five using a stump held on its side. Using the point of a stick eraser, stroke blades of grass in the foreground; then add subtle shadows to the base of the clumps with a medium-soft lead.

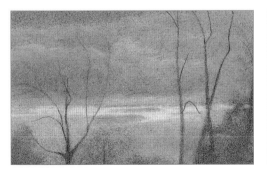

Creating Twigs To render the dark, thin lines of the tree branches, use a soft pencil honed to a sharp point.

Brightening the Sun To form the sun, pull out graphite with a kneaded eraser, leaving an imperfect circle for a realistic appearance through the clouds.

PROJECT 2: HORSE

This sturdy black horse has a playful but strong personality—one that I wanted to capture in this portrait. His mane falls on either side of his neck in twirling tendrils, providing an interesting contrast to his robust features. To render this abundance of textural details, I choose to work with watercolor paper that has a medium tooth, which will hold dark values and allow a supple look to be created for the coat.

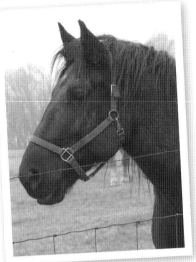

▶ **Distinguishing Values** I immediately take note that the values of the horse shown here are mostly dark, so there won't be much contrast. I make a conscious decision to lighten the mane a bit in my drawing, so the portrait doesn't become too monotonous.

◀ **Step One** First block in the general shape of the horse's profile on a large piece of paper, taking care to maintain the same proportions as the reference. Take a bit of artistic license and lengthen the back of the neck for balance.

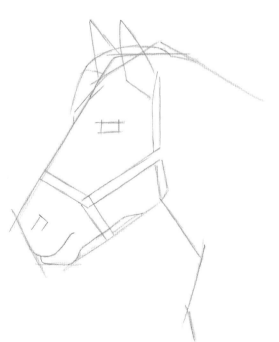

▶ **Step Two** Now indicate the eye, nose, mouth, and ears, constantly measuring and assessing the angles of each position; adjust them as you see fit. Then sketch the halter and define the shape of the chin and jaw. Add the brow ridge at left, noting how it angles away from the face; then draw the forelock (the hair between the ears).

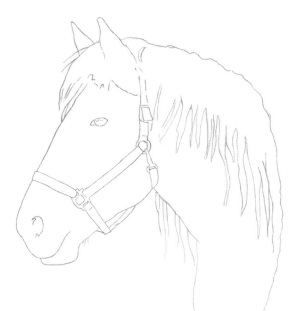

◄ Step Three Using your initial blockings as a guide, refine the outlines of the eyes, nostrils, muzzle, and mane. Next focus on the halter, curving the lines of the straps slightly so they show the form of the horse's head. Then erase any initial guidelines that you no longer need. Draw the horse's mane, adding tendrils that taper to a point. Round off the neck with a long horseshoe shape that contrasts with the angular quality of the horse's profile.

► Step Four Now transfer the drawing to a separate sheet of paper, and take note of the values based on the reference image. (You may want to use a photocopy of your drawing from step three instead.) Start by outlining the highlights and shadows on the horse's coat; then further delineate the variations in value. Next designate a value number to each area, using the value scale on page 15 for reference.

◄ Step Five Return to your original drawing and use a medium-soft pencil to fill in the lighter value in the horse's neck and a soft pencil to add the darker value. Hatch the area, and then smooth the hatching with a brush. Repeat those steps until each area reaches the desired value. Where the neck joins the body, lighten the hatching to delineate the area.

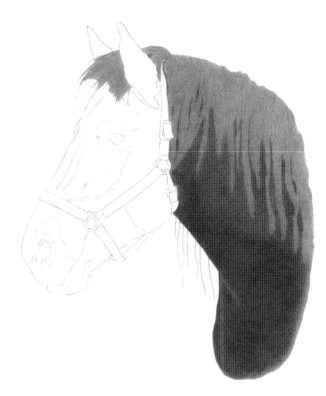

◀ **Step Six** Use a medium-hard pencil to fill in the mane. Apply varied long and short parallel strokes, deliberately leaving visible streaks within the vertical hatching to create a base for the mane's texture. Fill in the forelock in the same manner. Because hair like this is made up of rough light and dark strokes that blend together to make the value, it's a good idea to practice on a separate piece of paper that has the same texture as your final drawing; that way, you can determine what grade of pencil and combination of strokes will work best.

▶ **Step Seven** Fill in each value area with hatching and smooth it out with a brush until it matches the desired value. If a value becomes too dark in an area, use a kneaded eraser to pull out the graphite. Round the extension of the neck even more and continue to fade the edge. Pull out highlights in the metal parts of the halter with a kneaded eraser.

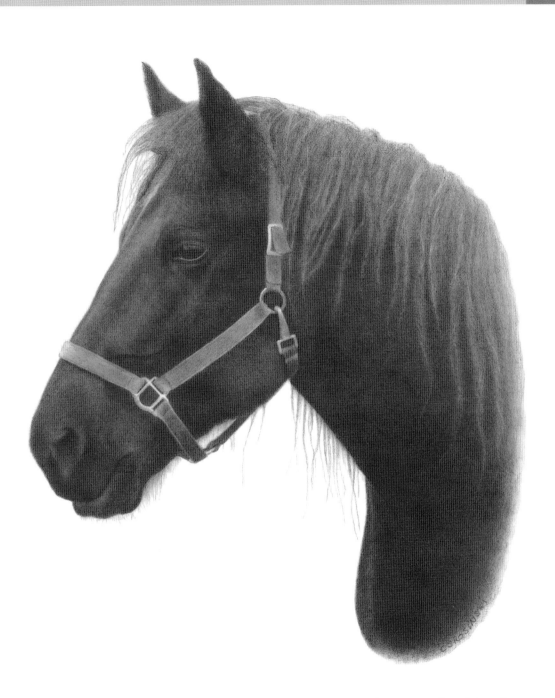

Step Eight Soften the texture on the cheek and neck, blending to draw more attention to the wispy mane. Then pull the medium-hard pencil over the mane with long strokes that follow the line of each twisting strand, making some areas darker for variations in depth. To finish the mane, add twisting highlights to some of the strands of hair, using a stick eraser cut into a point. Darken the far strands of hair and add a bit of fuzz on the horse's chin. Add the final details, including the shadows and stitching on the halter.

PROJECT 3: FLORAL STILL LIFE

When creating a flower arrangement, it's important to follow the rules of effective composition (see page 34). I place the vase slightly to the left to avoid a stagnant, overly symmetrical organization of the elements. Then I curve draped fabric or tissue paper around the base of the vase, bringing it off the opposite edge of the composition to lead the viewer's eye into the drawing. To give an informal touch to a classic subject, I lay some flowers on the table. Finally, I drape fabric in the background to create interesting folds and curves in the negative space.

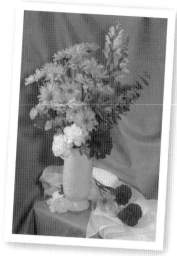

▶ **Creating Large Areas of Texture** For a mixed floral arrangement, I choose paper with a medium-rough texture; the tooth helps create interest within the large fabric background and makes the leaf and petal textures easier to render.

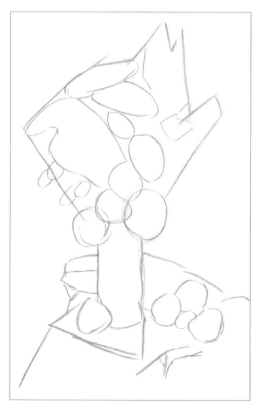

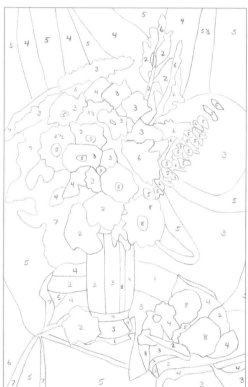

Step One For a complicated subject like this floral arrangement, block in the basic shapes of the largest objects before adding the smaller elements. To establish accurate proportions, use the vase as a reference for measurement. (In this case, the main bunch of flowers measures 1-3/4 vases high and wide.) Then loosely sketch the corner of the table and some of the large flower shapes within the bouquet and on the table.

Step Two Add the rest of the flowers by simplifying their forms, indicating only a general outline—you will add details later. After outlining every object, erase any initial sketchmarks you don't need. Then transfer the outline (or make a photocopy) and break each object down into values. Create a "map" on a separate sheet of paper, referencing the value scale on page 15 to assign a value number to each area.

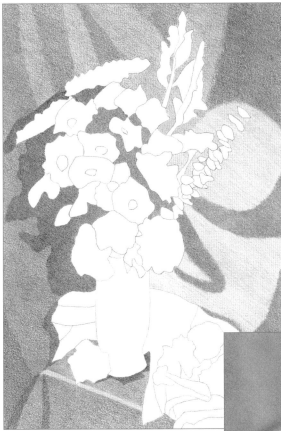

Step Three To protect the edges of your drawing from smudges of graphite, mask the edges with tape. Then use a soft lead to lay down the hatching in values that correspond with your "map." Crosshatch the darkest shadows first; then add a layer of hatching over the entire background to unify the darks and lights.

Step Four Smooth the entire background with a tissue until it creates a soft texture. To work in the negative space between the flowers, fold the tissue several times and use one thick, pointed corner to smooth the hatching. After blending with the tissue to create a soft, shadowy effect, the cross-hatched shadows remain darker than the single-hatched areas. Hatch the light flowers with a medium-hard pencil, following the shape of the flower's petals; for instance, apply the hatching on the daisies with strokes that radiate out from the center, as the petals do. Add the flower centers with a softer lead; then add values to the vase and tissue paper on the table using a brush and loose graphite.

Step Five Now add the middle- and dark-value leaves and flowers. Begin by hatching the stem and leaves on the right with a medium-soft pencil, blending with a brush for a soft, even value. Next apply horizontal hatching with a soft pencil over the carnations and the dark daisies; then blend the strokes with a brush. If any lights are lost in the blending process, pull them out with a kneaded eraser.

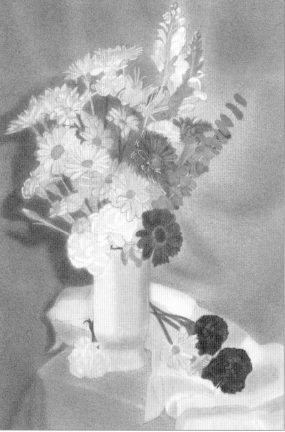

Step Six Now that you've established the basic value pattern, begin to add detail and give form to the elements. Shape the petals of the flowers by drawing into the edges of the flower shapes or by using a stick eraser to "push out" edges. Then use the same eraser to lift out highlights on the petals, as well as to pull out stems from the background. Use a medium-hard pencil to add more accents to the petals and flower centers.

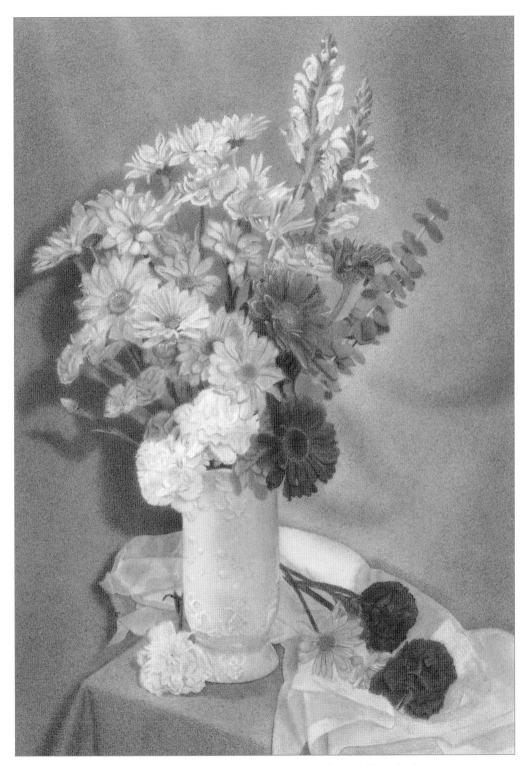

Step Seven Now add the raised pattern to the vase by further smoothing the gradation of value and pulling out the design with a kneaded eraser. Then lightly add shadows beneath the highlights of the raised area. As you proceed, hold your drawing at arm's length to check and adjust values, heightening contrasts by erasing to form lights and penciling in darks until you are satisfied.

PROJECT 4: PORTRAIT OF A GIRL

The adult human face features universal proportions, and subtle variations of these proportions create a likeness of a particular individual. Imagine a rectangle surrounding a face: The eyes are located about halfway down the center and are positioned about one eye-width apart; the bottoms of the ears line up with the bottom of the nose; and the corners of the relaxed mouth line up vertically with the pupils.

A child's facial proportions are slightly different than an adult's, as they haven't yet "grown into" some of their features. Children's eyes are farther apart and their noses are broader, flatter, and shorter. Their eyebrows usually are centered halfway down the head.

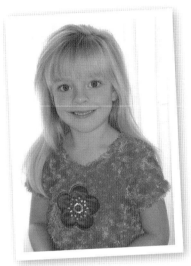

▶ **Paper Choice for Emphasis** Smooth paper will accentuate this child's youthful and flawless complexion, as it will allow the subtle gradations necessary to replicate her skin.

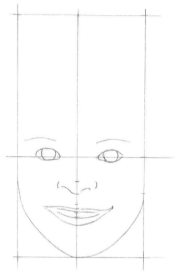

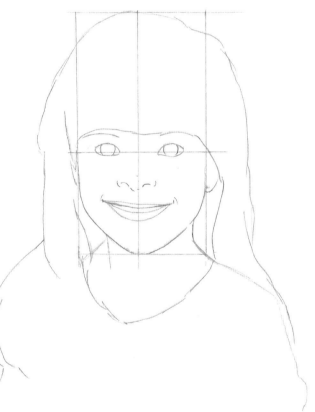

Step One Begin by marking the width and height of the face on your paper, and then use these marks to create a rectangular framework for the face. Indicate the position of the major features with dashes, taking care to maintain accurate proportions. Measure the height of the eyes in relation to the rest of the features; then lightly sketch in the eyes and nostrils, and use the relationship of the eyes to the corners of the mouth to sketch the mouth.

Step Two Lightly sketch in the hair, sweater, and neck, using the rectangle as a guide for placement. The right side of the neck flows into her jawline near the bottom of the mouth, and the left side flows out midway between her bottom lip and chin. Continue to use comparisons for size and placement of the features.

◀ **Step Three** Complete the sketch, adding smile lines, pupils, and teeth. Erase all the guidelines used for measuring, including the rectangle. Then transfer (or photocopy) the sketch and begin to indicate the value numbers. Using the value scale on page 15 for reference, mark a value number in each isolated area of the sketch. Use this numbered sketch as a guide for value intensity and placement on your drawing.

▶ **Step Four** Returning to your drawing, lighten all the lines on the face with a kneaded eraser using a gentle tapping motion. The lines should be visible but should not stand out sharply. Apply loose graphite onto the face and neck with a large brush to achieve about a #2 value. Then use a medium-hard pencil to smoothly hatch the shadow areas; hatch the shadows with a value that is a shade lighter than desired—the hatching will darken as it is manipulated with brushes and stumps in step five. Next use a medium-hard pencil to fill in the irises, lips, and gums.

◄ Step Five For the hair, match the middle value by hatching with medium-soft pencils. Stroke in the direction that the hair grows so that the pencil marks help to create the proper texture. The hair is not as important as the facial features in a portrait, so you can use minimal detail. Simply hint at the hair's mass by laying down the basic values, pulling out the highlighted areas with a kneaded eraser.

► Step Six After completing the hair, work on the sweater texture by cross-hatching with a medium-soft pencil. Add darker hatching where the arm creases the sweater, but keep the markings indistinct so that the face remains the focus.

Drawing the Eyes

Step One Use a medium-soft pencil to outline the iris, pupil, and lids. Then indicate the curvature of the eyebrow and the edge of the nose.

Step Two The "white" portion of the eye is a #2 value, so darken the entire area accordingly using a brush and graphite powder.

Step Three Using a medium-hard pencil, lightly hatch in the shadow areas around the eye, including the upper lid and the top of the cheek.

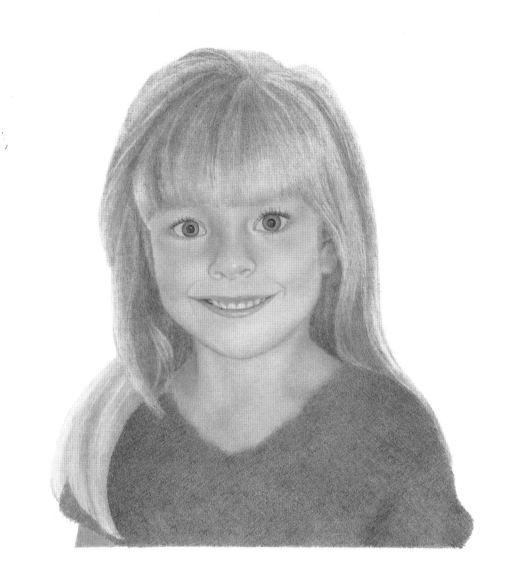

Step Seven Use a brush and a stump to gently rub and stroke the hatching, darkening and smoothing the skin. Graduate the values along the nose and add a highlight on the tip using the sharp point of a battery-powered eraser. Use a medium-soft pencil to add dark details to the eyelids, pupils, irises, nostrils, and corners of the mouth. Then lift out a highlights in the corner of the left eye, on the bottom lip, and on two of the teeth. Finally, smooth the texture of the hair and add thin highlights with a kneaded eraser formed to a point.

Step Four Darken the outline of the eye and iris, radiating the strokes outward from the pupil. Then darken the shadows using a brush, loose graphite, and a stump.

Step Five Outline the iris and fill in the pupil, working around the highlight. Smooth the iris with a stump; then darken the eyebrow and corners of the eye.

Step Six Use a soft pencil to stroke in the upper eyelashes, followed by the lower lashes with a hard pencil. Pull out highlights in the corner of the eye.

PROJECT 5: FRUIT & WINE

When using only pencil—essentially a range of grays—incorporating contrasts of texture and value into your drawings is important for creating interest. In this scene, the sharp, crisp highlights on the wine glass, bowl, and pieces of fruit nicely contrast against the soft, velvety fabric background. Also the light values of the pears and grapes are a great complement to the dark background.

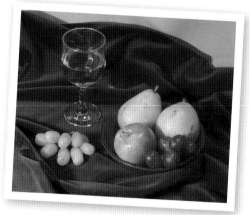

▶ **Choosing Paper** The soft folds of the fabric and sleek surfaces of the fruit's skin call for a smooth watercolor paper.

◀ **Step One** Using the technique on page 18, measure the height and width of the triangular composition formed by the wine glass, grapes, and bowl of fruit. Transfer this basic shape to the center of a large piece of paper. Then block in each element of the scene. Because the viewpoint is high, the circular shapes of the bowl and wine glass become ovals.

▶ **Step Two** Now begin refining the outlines of each element. Indicate the level of the wine in the glass and each grape in the cluster below the glass. Then add the edge of the bowl, and sketch the fruit, taking care to maintain the proportions shown in the reference photo. When everything is in place, erase the initial guidelines.

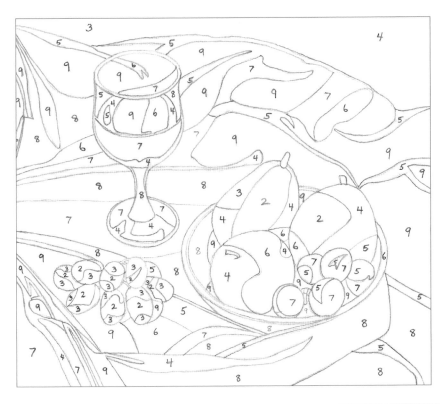

◀ **Step Three**
Next draw the upper curve of the cloth, noting how far it is above both the glass and the bowl in the reference. Then draw the wrinkles and folds of the cloth. When you are finished, transfer the drawing onto another sheet of paper (or photo-copy the sketch) and assign a value number to each area according to the value scale on page 15. Use this as a guide for value intensity and placement.

▶ **Step Four**
Prepare a pile of loose graphite and fill in the far wall (at top) using a wide brush. Graduate to a slightly darker value on the right side to add interest to the negative space. Take your strokes down past the top of the fabric to make it appear as though the fabric is in front of the background. Then add a range of medium and light values in the folds, on the fruit, and in the glass using a smaller brush and loose graphite.

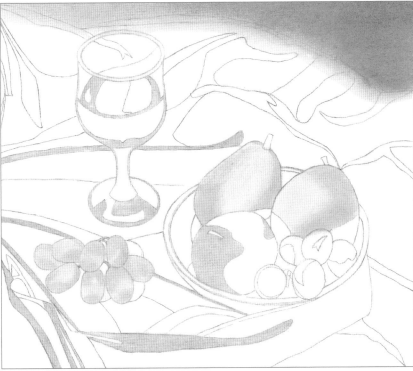

Creating a Wine Glass

◄ Step One
Draw the outline of the glass, and then squint your eyes to see the shapes of the values in it.

► Step Two
Use tight hatching to fill each area with a range of dark and medium values.

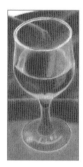

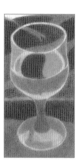

◄ Step Three
Smooth the separations in value using a small brush. Then begin hatching and smoothing the darkest areas of the wine glass.

► Step Four
Add details using a sharp soft lead for the shadows along the base of the glass and within the stem. Then lift out highlights with a stick eraser, accenting the edges of the glass for a sharp contrast to the dark cloth.

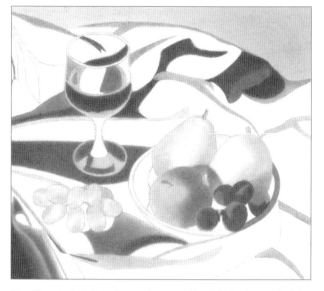

Step Five Apply darker values to the composition, bringing form to the fruit and further establishing the folded pattern of the fabric. Use medium-hard and soft pencils, depending on the value. Hatch each area, smoothing the hatching with a small brush and repeating the process until the area reaches the desired value.

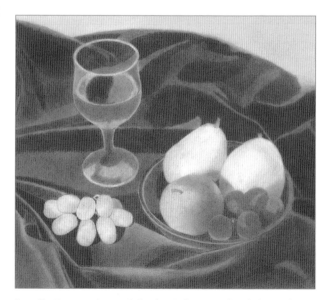

Step Six To create the very dark values in the surrounding cloth, use sharp, very soft leads for hatching. Follow each layer of hatching with a brush to smooth out the lines, repeating this until you achieve the darkest darks. Because it's possible to lift graphite by brushing it, keep your brush smoothing to a minimum as you approach the final value.

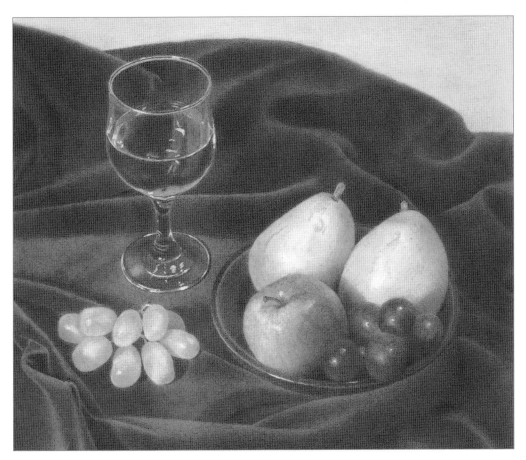

Step Seven In this step, gradually blend the dark areas of the cloth into the highlighted areas of its folds using soft leads and a brush. The dark grapes are similar in value to the bowl, so pay careful attention when separating the grapes' edges from the bowl and from one another. Looking carefully at the shadows that the lighter grapes are casting on one another, apply more graphite to the bodies of the grapes using a small brush. Add a grainy texture to the pears with hard lead followed by light brushing. For the apple, use a kneaded eraser to lift out highlights and a hard lead to add subtle dark stripes. To finish the drawing, create the sharpest contrast possible by pulling out crisp highlights on the fruit, bowl, and wine glass with a battery-powered eraser.

CLOSING THOUGHTS

As a note of encouragement, I'd like to remind you that a path leading anywhere is best followed one step at a time. This is true of life as well as art! To finish a drawing, you need to work on it step by step; to become accomplished in this medium, you need to create one drawing after another. And to be an artist, simply continue down this path of self-expression—step by step, drawing by drawing.

As you travel, don't forget to look back at your earlier drawings every now and then. Your progress will amaze and delight you—looking back to see how far you've come will inspire you to keep drawing and growing artistically. Enjoy the journey!

Ash Tree with Wild Flowers by Carol Rosinski